GOLDFINCHES & DANDELIONS

Inspiration Derived From Pan European Cuisine

JOSHUA DEVLIN

PHOTOGRAPHY BY JOSHUA DEVLIN

978-1-80541-314-1 (Paperback)
978-1-80541-315-8 (eBook)
978-1-80541-316-5 (Hardback edition)

CONTENTS

INTRODUCTION

FIRST THINGS FIRST, it must be stated that cookery and '*foodism*' isn't a dictatorship. As home cooks, we're free from the hierarchy of the professional kitchen and the adherence to tradition that goes with it. We are free to choose alternatives to ingredients by using what we have on hand or simply prefer. Think of these recipes as templates, a way of approaching the culinary world – low waste, intensely flavoured, accessible food that is seasonal and locally produced.

Passion for food can be a slow simmering affair or something we don't even realise is there until its clicks. We all love good food made with wonderful ingredients, but when can we define that moment of ignition within us that makes us care further about producers, our health, and our heritage? Truth be told, everything is linked, and if you care about the environment, you'll care about how food is grown or extracted from it. If you care about flavour, you'll need to care about the people who understand terrain, technique and growing methods.

As children, we seemed to understand the importance of food. At least 50-75% of my childhood memories involve food in some shape or form. The fruit trees and bushes in the garden, your favourite sweets, and undoubtedly the hated items forced upon us. (Boiled veg stew with supermarket sauces and black bean burgers stand out). But its importance and value seem to be forgotten over the years as we focus on the demands of life and give in to convenience and naughty habits. For some, it may always be a strong passion, but often, we need experience to pull us to this revelation, reminding us how simple joys such as food are some of the greatest and most commonly found.

The best way to experience and gain experience is through immersed travel. Without this, it's harder to understand the concepts of authenticity and freshness. Travel provides the space to learn and gain knowledge first hand often through mistakes. Recalling an early school holiday to Brittany, France, one of the few memories that remain of the trip is my finding of a thick rind piece of cheese to bring home or trying (not to great satisfaction) a large hunk of meringue from a patisserie. Why? Because it's what you do, right? Let's just say it's best to get these things out of the way and under your belt as soon as you can. Other, less half-baked adventures involved looking with intrigue at parcelled fish steaming up towards my

grandmother's face in a café in the Belgian capital of Brussels. The point is that building the palate through experiences is vital.

Creating my own adventures as an adult always revolved around lunch and dinner. With some of the most idyllic and spectacular scenery and cities in the world residing in Europe, it would be easy to let the culinary side of things slip to the back burner; they never do. The experiences in restaurants and gastronomic halls stand just as proud and statuesque as the mountain ranges that often inspire and provide for them. The smell of sweet, pungent neroli floating through the hot air of a citrus grove in Malta rivals any grand square or cathedral; it's all part of the fabric.

This is one way the modern prevalence of travel has created a common thread for us. Many more of us have these memories for which passion can grow. There's no country, people, or creed that strives to create bad food or, for that matter, doesn't enjoy sharing their most emotionally charged, comforting, or culturally relevant foods. It's been the pretext for much of my travel and connections. With food touching all areas of our life, it's easy to find a specific entry point. This could be health, environmental or ethical. Perhaps the lockdowns of 2020 reminded us what the kitchen garden was and how needed it is for our minds and well-being. Whatever the reason, now is always the best time to focus on good food. Gain some tested experience through this exploration of Europe's culinary hotspots.

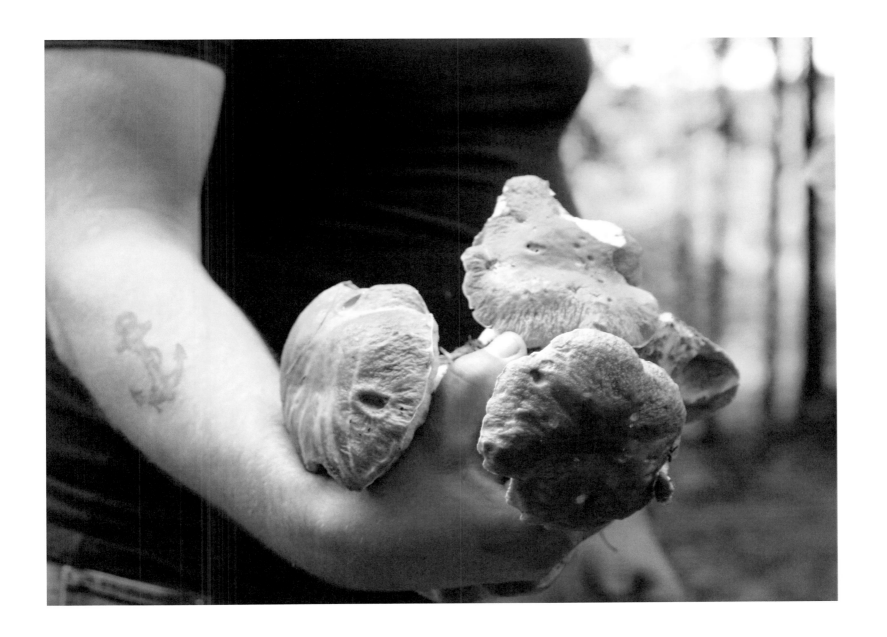

SMALL DISHES & SNACKS

2

SERVES

Marinated Feta

Little creations and dishes like this really get the creative juices flowing with food. They can be a space for you to start working with flavours you like or think may work well, with little risk.

As well as this, you can really layer your thoughts. For example, many of the ingredients you can sprinkle on can have health benefits. I used turmeric for this purpose, but I also think of seaweeds, salts, and other seeds.

INGREDIENTS

Feta block

Olive oil

Salt

Pepper

Dill seeds

Fennel seeds

Turmeric

Chilli flakes

2 medium oranges

INSTRUCTIONS

1. If you're going to use this as a dinner or salad side, cut the feta block into slices about an inch thick. You can go more delicate if you desire. You can also cube the cheese if you want to make marinated bite-size pieces. These are perfect snacks for on-the-go.

2. Sprinkle over the turmeric, salt, pepper, and chilli flakes. Squeeze two halves of an orange over and then add the seeds. With these, you may want to crush them a little to create more aroma.

3. Leave for 4-6 hours before serving. If you do 24 hours, the flavours will be much more profound. If you have a vacuum seal, then you should use this to infuse the flavours into the cheese. With this method, the feta can also be left to infuse for days.

Andalusian Gazpacho

4
SERVES

INGREDIENTS

500g of vine tomatoes

3 capsicums

3 garlic cloves

Canola oil

Extra virgin olive oil

White pepper

Thyme

1 tbsp crème fraiche
(and some as a garnish)

1 cup vegetable/mushroom stock

INSTRUCTIONS

1. Roast the capsicum and vine tomatoes in an oven preheated to 180-200°c. Before placing them in the oven, halve them and give a good drizzle of canola oil and a pinch of salt. Once the capsicum has just begun to char, remove the lot from the oven and set aside in a saucepan.

2. Throw in three garlic cloves, some thyme, and a punchy amount of white pepper. Using an emulsifier, blitz the mixer down as fine and smooth as you can. Seeing the consistency, add some stock.

3. You want a thin soup that's refreshing but, of course, packing flavour. The ratios can be adjusted to your own taste. For example, if you enjoy garlic, add a little more. This is important when making sure you have enough capsicum for that rich roasted hit.

4. Once a desired consistency is reached, add a tbsp of crème fraiche and blitz once more.

5. If you so wish, garnish with a small dollop of crème fraiche and a swirl of extra virgin olive oil. Serve chilled.

2

SERVES

Baked Baby Beets

Easy and utterly delish, this is a great spring or summer dish. Snap up the baby beets as they come into season! You will not regret the sweetness and depth of their flavour.

INGREDIENTS

10 baby beets
5 tbsp Greek yoghurt
1 tbsp honey
4 bay leaves
Thyme
Lemon zest
Water

Optional: Sea salt,
extra virgin olive oil
or canola oil

INSTRUCTIONS

1. Fill a medium baking tray at least four inches deep with water and place in 4 bay leaves. Cut the greens from the beets if they are any. Keep them to one side, as these are lovely when sautéed. With their skins on, place them in the water. Cover first with clingfilm, then aluminium foil.

2. Place in the oven at 200°C for 1.5 hours or until soft but with a little bite left in the centre. The time will vary based on size and exact type of beet, so pay attention; you don't want it to turn to mush.

3. When they are cooked, you can take the beets out of the water and, with a paper towel, gently rub the skins, and you'll find they easily come loose.

4. Mix 5 tbsp Greek yoghurt with 1 tbsp honey. Add in fresh thyme leaves and lemon zest.

5. Place the beets in the centre and enjoy with a crack of sea salt and extra virgin olive or canola oil. Smoked salt or oil, if possible.

2-3
SERVES

Basil Pesto

INGREDIENTS

250g basil

4tbsp pine nuts

Salt

Pepper

5 tbsp extra virgin olive oil

3 tbsp parmesan cheese (Grated)

INSTRUCTIONS

1. With a mortar and pestle, break down the basil leaves with a heavy pour of olive oil – say 5 tbsp. When breaking the leaves down, try to smash them rather than mushing or dragging them. Breaking open the cell walls of the leaf over mashing it should help create a stronger aroma, which is what basil is all about, after all.

2. After this, add in the pine nuts, salt, and pepper. Mash these down, leaving the pine nuts loosely broken to provide some texture.

3. Lastly, add the grated parmesan cheese and work this through with a spoon. Make sure there's enough extra virgin olive oil, and it's seasoned to your taste. This will last 3-5 days.

Glazed Carrots

3
SERVES

INGREDIENTS

400g carrots
50g butter
Salt
2 oranges
Thyme
Nutmeg
1 tbsp brown sugar

INSTRUCTIONS

1. Pop the 1cm thick diagonally sliced carrots into a hot frying pan with butter. Do not heat the pan to the point the butter burns. Watch for smoking. When the carrots are in, add 1 tbsp of brown sugar to the butter and let this melt down.

2. As the carrot slices cook, you must spoon over the buttery goodness. Of course, when cooked until only slight resistance remains and plated, they should be doused with butter.

SERVES 2

Mushrooms On Toast

INGREDIENTS

250g fresh mushrooms
Boursin herbed cream cheese
Thyme
Butter
Black pepper
Salt
Loaf of sourdough bread
Olive oil
1 clove of garlic

INSTRUCTIONS

1. Prep the mushrooms by washing and removing any undesirable bits. Heat a knob of butter in a frying pan with a dash of olive oil. Throw in the mushrooms and add salt, pepper, and thyme to taste. Fry these until they start to caramelise and brown. If they appear dry, add more butter to enrich them.

2. Once they have a nice browned colour, add half a round of Boursin cheese and melt it into the mushrooms. The mix may appear slightly dry, so add butter to smooth the consistency.

3. Slice a sourdough loaf and toast it in a frying pan with butter until slightly browned. Once done, rub a garlic clove over the bread.

4. Portion the mushrooms well, crack some black pepper, and serve hot!

Cauliflower Salad

4-5
SERVES

INGREDIENTS

1 large cauliflower
Pomegranate
Olive oil
Salt
Tarragon
Garlic
Orange

INSTRUCTIONS

1. Slice the cauliflower in half and place onto a hot griddle with olive oil. Leave it for a few minutes until some char marks have started to form, and flip them to achieve the same on the other side as well. Add a few garlic cloves to the griddle and let them caramelise.

2. When done, take off the florets, making sizes of roughly an inch all around. Don't discard the stem; dice it into inch cubes.

3. Segment the orange and prep the pomegranate. Combine the cauliflower, garlic, and orange segments.

4. Finely chop the tarragon and zest a lemon, being cautious to avoid the bitter white pith. Mix all the ingredients in a serving bowl thoroughly.

5. Finish with a dash of olive oil, a pinch of salt, and a crack of pepper.

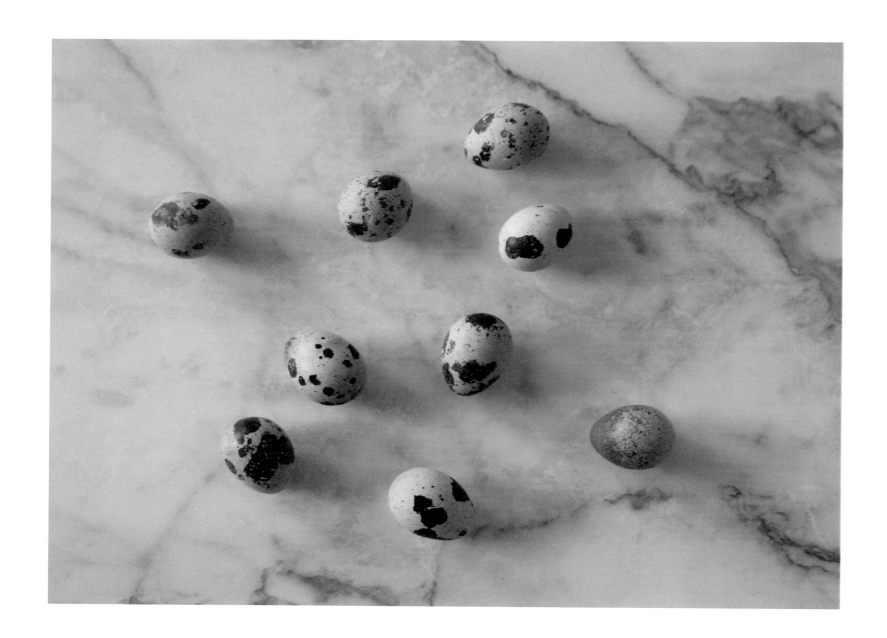

Quail Scotch Eggs

You can use any eggs for this recipe; it's surprisingly fun, easy, and customisable. Once you've got it down, you'll do it without any recipe your way and be everyone's favourite for at least one day.

INGREDIENTS

6 quail eggs
250–300g minced pork
White pepper
Salt
Nutmeg
Thyme
2 medium eggs
150g flour
150g panko crumb
2 tbsp parmesan/hard cheese

INSTRUCTIONS

1. Combine the minced pork with a liberal crack of white pepper and a good pinch of salt. Grate some nutmeg finely and add thyme leaves. Using your hands, thoroughly mix.

2. Get a pan of water to a rolling boil and cook the quail eggs for 2 minutes. They should still be soft in the yolk and, hopefully, a little white, also. This is important as they will cook further later. Take great care with these fiddly little eggs. Once peeled, set aside.

3. Whisk two chicken eggs in a bowl. In another bowl, pour in 150g of flour. Mix this with a touch of finely ground white pepper. In a third bowl, set out 150g of panko crumbs and grate two tbsp of parmesan or other hard cheese into this. If you don't have panko crumbs, then grate or smash stale bread to a similar consistency.

4. Form the minced meat gently around the quail egg, remembering its soft inside. Once there is a 1-2cm thick layer around the egg.

5. The order to coat these in the crumb is simple: flour, egg, crumb, egg, crumb. The double process at the end will ensure the correct coating.

6. Drop these into a fryer that is already at temperature. Cook until golden brown.

2-4

SERVES

Twice Cooked Carbs

INGREDIENTS

*3-4 large baking
potatoes
4 tbsp salt
Black pepper
Olive oil*

INSTRUCTIONS

1. Boil a pan with 4 tbsp of salt and water. When it's reached a rolling boil, add 2 x 2-inch cubes of potatoes. Cook these until they fall off a knife when jabbed.

2. Drain the potatoes well and place them onto paper towels to get rid of extra moisture, then into a baking tray. Preheat oven to 230°C. Coat the potatoes in olive oil, salt, and pepper. Cook for 30-40 minutes or until well browned. Turn them after 15 minutes.

3. Empty these into a paper towel-lined dish before plating, and think about an aioli.

Cilantro Tomato Salad

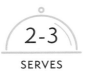

This zingy and fresh dish is a perfect summer salad or everyday side dish.

INGREDIENTS

1/2 kilo of orange and red vine cherry tomatoes
Bamboo jade salt
5 ground corns of smoked black pepper
1/2 lime – (Juiced)
3 ground coriander seeds
1/2 tsp of fresh rosemary
1 tsp of ground dill seeds
Extra virgin olive oil
Parmesan cheese

INSTRUCTIONS

1. Wash and slice the vine cherry tomatoes in half. Add enough extra virgin olive oil to cover most of them, and start adding the ground seeds. Add a heavy pinch of coarse salt.

2. Squeeze the juice of half a lime and add coarsely chopped cilantro and rosemary and mix until evenly incorporated.

3. Grate some parmesan over the salad and mix it in. Then grate a touch more over the top to finish.

6

SERVES

Nettle Bread

INGREDIENTS

500g flour
15g yeast
300ml warm water
200-250g stinging nettle
leaves
10g of salt

INSTRUCTIONS

1. Preheat the oven for 20 minutes at gas mark 8.

2. First, mix flour and salt, then add the yeast to the mix. Mix thoroughly and create a well in the flour. Make a depression in the centre to add water slowly. Incorporate water until a smooth dough is formed. This can take 5–10 minutes.

3. The nettles (*if stinging*) will need to be blanched to remove the little irritant hairs that cover their leaves. Boil water and blanch them for 2 minutes tops. Take them out, pat dry, and mince the leaves finely. Pat dry again to remove excess water from the mix and incorporate them into the dough. Let it sit for 5 minutes before kneading.

4. Knead the dough for a further 15 minutes to create elasticity in the bread. Make sure to dust the counter with a little flour so it handles easily. Once this is done, smooth the dough into a rounded shape and let it sit until the dough has doubled in size.

5. Cook in the oven for 30–40 minutes (*or until golden brown on top*).

6. Best had with some honey and oil. It's a delish treat, and the nettles bring a wonderful herbal flavour while adding many nutrients. An instant favourite that upgrades any soup. Think about adding nettles to pizza or flatbread bases!

Honied Goats Cheese

4
SERVES

INGREDIENTS

150-250g soft goats cheese
Thyme, rosemary,
black pepper
2-4 tbsp honey
1 tbsp olive oil

INSTRUCTIONS

1. Mix the herbs and pepper to taste, adding olive oil and mixing until all of the ingredients are smooth and incorporated well.

Toasted Baguette

INGREDIENTS

Baguette (fresh or otherwise)
Olive oil
Thyme
Lemon zest
(Lime or Orange also works)

INSTRUCTIONS

1. Heat oven to 180°C and coat the slices of baguette in olive oil. Zest your citrus over the slices, making sure not to zest into the bitter pith.

2. Toast until golden brown and delicious; 7-10 minutes.

3. Healthy alternatives to carbs can also be used, such as veg sticks.

Eggs Sur Le Plat

2-3
SERVES

INGREDIENTS

4-6 medium eggs
Mushrooms (Chanterelle,
PieddeMouton, Cepe, Morel)
Smoked ham
Pepper
Salt (Fleur de Sel)

INSTRUCTIONS

1. Preheat the oven to 200C. In a shallow bake dish, crack 4-6 eggs, making sure the eggs are no deeper than 3-4cm. Once you've cracked the eggs, arrange the yolks in a preferred way, and sprinkle over the prepped mushrooms of your choice. Loosely break apart some slices of smoked ham and add these.

2. Give a pinch of fleur de sel to each egg yolk before placing it in the oven for roughly ten minutes. This is a wonderfully quick and easy meal or snack that is both healthy and filling.

2

SERVES

Corn on The Cob With Chilli and Feta

INGREDIENTS

100g feta
Chilli flakes
Lemon
Salt
Corn on the cob

INSTRUCTIONS

1. Boil the corn on the cob in salted water. This will take no more than 5 to 10 minutes, depending on the amount. When they're cooked, take them out and place them onto a towel and let them steam off.

2. In a bowl, crumble the feta down with a spoon, zest some lemon into it along with a pinch of salt, and mix. Coat the corn cobs in the feta mix and then sprinkle over chilli flakes.

3. To serve them, use corn holders or serve on a stick. Keep it easy and informal.

Sumac Popcorn

2
SERVES

This is an absolute favourite of mine for any movie night.

INGREDIENTS

180-200g popcorn kernels
Sumac powder
Canola oil

INSTRUCTIONS

1. Heat canola oil in a frying pan until it just starts to smoke, and add the popcorn kernels. Have a lid to hand. You know why!

2. Once the kernels have popped, put them into a paper towel lined bowl to remove any excess oil. Flip out the paper towel and sprinkle with sumac, tossing the popped kernels to coat evenly.

3. Here is a tip to try, as I grew up with sweet popcorn – it often divides people, but you can try adding a touch of brown sugar to the sumac, and you create a punchy sweet and sour combo.

EUROPE'S CULINARY CITIES

WHEN THINKING OF fine food and culinary prowess in Europe, you would almost be forgiven for blurting out 'France!' or 'Italy!'. While these antiquated bastions stand bright and everlasting in the world of impeccable flavours and methods, there are some new kids on the block finally able to share in that spotlight.

First of all, must be the Dutch capital of Amsterdam. This is a true melting pot. There is top-notch cuisine from around the world here, from pizza and sushi. Being Dutch, they take it upon themselves to perfect the lot. And while there are a plethora of amazing restaurants and Michelin stars, it is also the food halls and markets that make this a culinary hotspot on the continent. The Albert Cuyp market is probably the largest, but the weekend operating Noordermarkt is the best I've found. Found in the hip neighbourhood of the Jordaan, it has a bit of everything, but the specialists are where it's at. A mushroom purveyor and herb grower are among my most loved in the market between them, giving me a real knowledge of the unusual. It is rare to see something new on every visit when you have been going for years, and this market never disappoints – unless you get the day wrong and show up on the day it is a flea market.

Barcelona is the capital of Spain's almost free but smacked-down region of Catalonia. Horrible federal police and politics aside, its culinary heritage and vibrancy are second to none on Spain's Mediterranean coast. Its size creates the type of markets and food halls found only in the world's most prestigious cities, and the quality of the food is second to none. This isn't due to flashy bankers or elites; rather, this comes down to the average Spaniard demanding the best produce around. Fruits like citrus and melons are piled high everywhere, and the seafood is out of this world. There are copious shellfish and

the unbeatable Galatian octopus combined with many fish – A lot of deep water and unfamiliar to most. If you're there in the summer, it will be an utter treat. Take your time walking down the streets and make lots of stops. Grab a drink or cocktail, stop off for a little gelato and make sure you don't miss anything in the heat.

One more city of divine culinary right would be Copenhagen, the Danish centre of everything. In a small and relatively dull country, the standout of this city is food and food alone. It's a serious affair here with many Michelin stars and aspiring chefs. This, for me, created an experience which, by the end of seven days, meant I was so overwhelmed and overindulged I could hardly finish a meal. It is a cutting-edge culinary scene and embodies the Nordic approach. They use local, sustainable produce coupled with traditional techniques to great effect. There is a precision around their food that is near impossible to replicate or find anywhere else. The kicker is that this is largely achieved using vegetables and making meat a secondary role. Restaurants come and go, but the ethos and motif of this city's culinary heart are always to be felt. Go and explore!

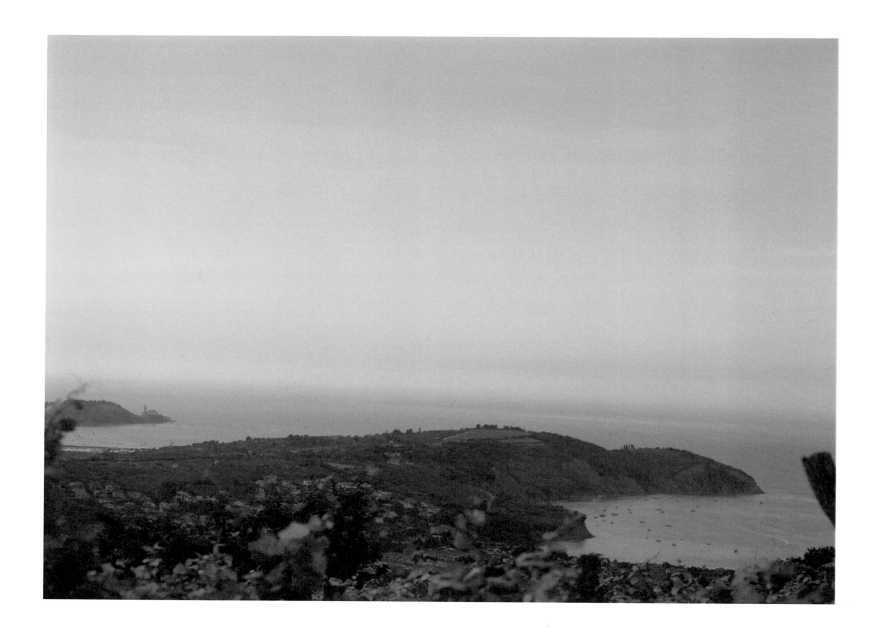

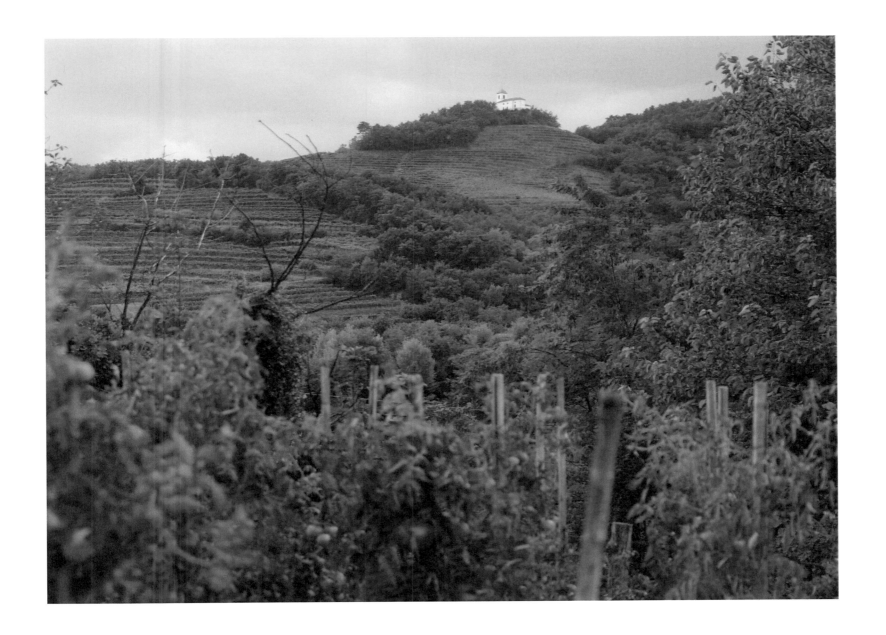

SLOVENIAN FOOD ETHOS

SLOVENIA IS TRULY a country whose culinary talents stand proud and defined. The whole ethos of the country is based on sustainable, wholesome food. To explain – they live for the '*kitchen garden*'. Not just any kitchen garden, the type seen in Britain or Switzerland – these are meticulous, individualised, seasonal affairs that use every available square inch of space. Terraces covered with tomato plants, walls clung to with vines laden with bunches of black or golden grapes. Every inch has something to offer. The vertical space mastered they are really something of envy and what my own kitchen garden is based on.

Autumn is the best time to see this, as you'll find fruit trees laden with plums, apples, plus walnuts and many other treats. Best yet, it's when the kitchen garden itself has come to fruition. Beans are reaching high, and gardeners are taking full advantage. It's a pleasure to see others work their spot collecting dinner. One of my best memories would be of a small village mid apple cleanup. Fallen apples line the road from the copious trees growing alongside it, with people eagerly collecting any shape and size before flinging them into wheelbarrows to be carted off for juice.

As a side about Slovenia, I have also had the privilege of being in the country for the mushroom season in the autumn. On one occasion running into a group of very muscular men with a white BMW dressed all in black. Clearly, some type of hard men, who knows what they were doing, going through the wood collecting cepe mushrooms – a real prize, treasured throughout Europe and the rest of the world that you might know as porcini if you've Italian roots or penny bun if you've English. I slowed down the car to ask them about their finds, and they were over the moon to explain what they were doing and show off their haul so far – one constantly shouting deeper into the woods for another member of their foraging party.

It proved to me a common thread of life – the desire for delicious, wholesome food we had some part in growing or finding and the fact that food and produce can bring people with nothing else in common together. Wrapping up, they let me snag a few pictures of the absolutely envious mushrooms, and I was on my way before they decided I might go nicely with them. A moment and interaction seared into memory.

But there's far more than just the humble kitchen garden or forager; Slovenia is home to some of the most perfectly positioned vineyards acutely nestled into hilltops and terraced terrain, with mountain tops crowning the vines offering their golden and mauve fruits trellised in at least five methods to capture the most of the sun's energy. A feeling of awe is hard to escape.

MAINS

2

SERVES

Steamed Whole Fish with Veg

This is a great recipe for a few reasons. It's easy, healthy, and most fish can be used – from bass or bream to trout and char.

INGREDIENTS

Vine cherry
tomatoes

Chive

Asparagus

Lemon/orange

Salt

Peppercorns

Butter

Bay leaves

Whole fish
(around a half kilo)

INSTRUCTIONS

1. Get a whole fish around a half kilo. Have it prepped if it isn't already. If you can, get or leave the head on.

2. In the lower levels of the steamer (*or the water it's placed in*), you can add herbs and other tasty bits. Put some bay leaves into the steaming water with peppercorns. Place some fresh chives on the lower level of the steamer. This won't be desirable once the fish is cooked. Being a soft herb, it will have completely broken down, but not before imparting some fragrance upward towards the fish and veg.

3. The fish will take roughly 10-15 minutes to steam, based on size and firmness of flesh. Before you place it into the steamer, stuff some slices of citrus into it. Arrange it in the steamer, and don't worry about making it fit gently – it's dead.

4. With 5 minutes remaining, open the steamer to check if the fish is softening and cooking through properly. Take this opportunity to put the asparagus and vine cherry tomatoes in. They go in later being delicate and quick to cook; we don't want mushy veg.

5. When the fish is cooked, the skin will peel away with ease, and you can gently remove each fillet from the sides and the cheeks of the fish.

6. Serve up with the veg, adding melted butter and salt to the asparagus. (*The more health-conscious can use extra virgin canola or olive oil*).

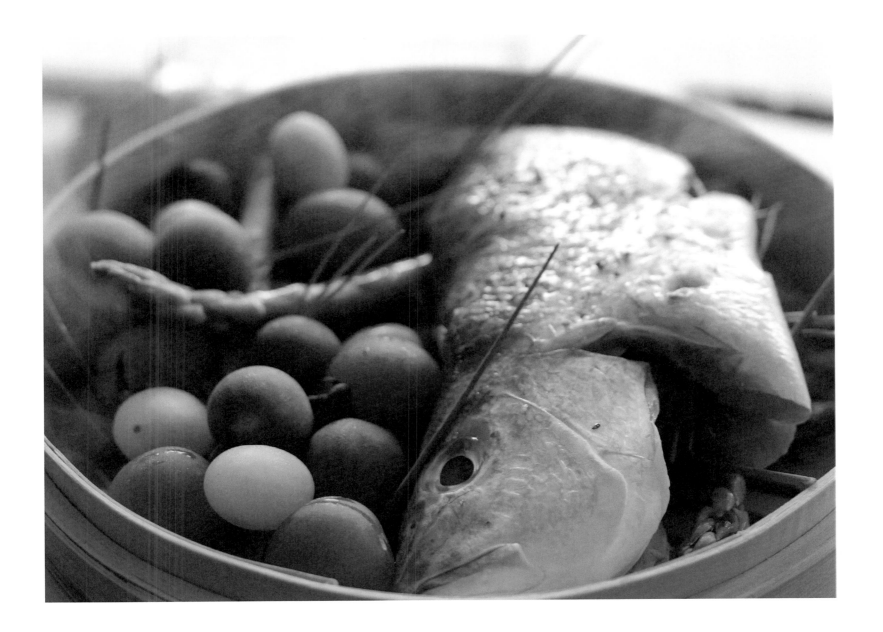

SERVES 2

Chorizo and Nectarine Salad

INGREDIENTS

200g chorizo

3 nectarines

Any salad leaves

Rocket

100g walnuts

Olive oil

200g manchego cheese

Capers

INSTRUCTIONS

1. Keep the chorizo at room temperature to keep the fats and texture as they should be. Crush 100g of walnuts. Slice 200g of Manchego into thin triangles. Wash and slice your salad leaves, leaving the rocket whole.

2. Now for the fun bit!

3. Slice the nectarine cheeks from the stone and slice into thirds. Mix with chorizo slices. Layer on salad leaves, a sprinkle of rocket and the meat and nectarine mixture. Sprinkle over the cheese triangles, crushed walnuts, and capers. Lastly, drizzle with a dash of good extra virgin olive oil.

Crab Salad

2
SERVES

INGREDIENTS

*Whole brown crab
(approximately 200g
cooked)*
Baron onion/shallot
3 tsp live yoghurt
5-8 green peppercorns
250-300g potatoes
1 lemon (unwaxed)
2 tbsp butter (melted)
3 tbsp water (hot)

INSTRUCTIONS

1. Break down the crab, taking only the white meat from the legs, chest, and claws. Leave this in nice chunks. You should have around 200g of white crab meat. Put this into a bowl and add three tbsp of live yoghurt and minced baron onion, spring onion, or shallot. An onion with varying forms will serve best, as having some extra green serves well. It's fresh and herbaceous.

2. Coarsely grind 5-8 green peppercorns and add this to the mix. Zest an unwaxed lemon on three sides and then half, adding the juice of one if small or a healthy squeeze if a larger lemon.

3. Mix and combine thoroughly.

4. In a large pan, boil water with sea salt and add cubed potato. When these are cooked, take them out and let them cool. Put through a ricer and mix with two tbsp of melted butter and three tbsp of hot water.

5. Using three-inch deep rings in the centre of a plate, fill one-third with potato, making sure to smooth it down to fit the ring. Using the thinly sliced bulbous portion of the baron or spring onion, place some to divide the layers.

6. Split the crab mixture between the two portions, filling most of the remaining two-thirds.

7. Garnish with garden flowers if possible. Geranium or nasturtium are common, easy to grow, and work well!

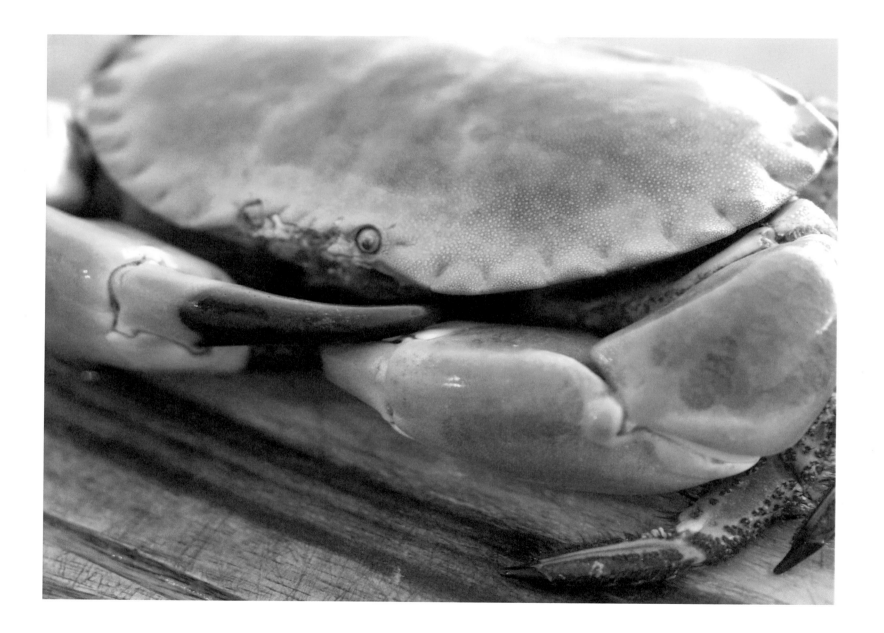

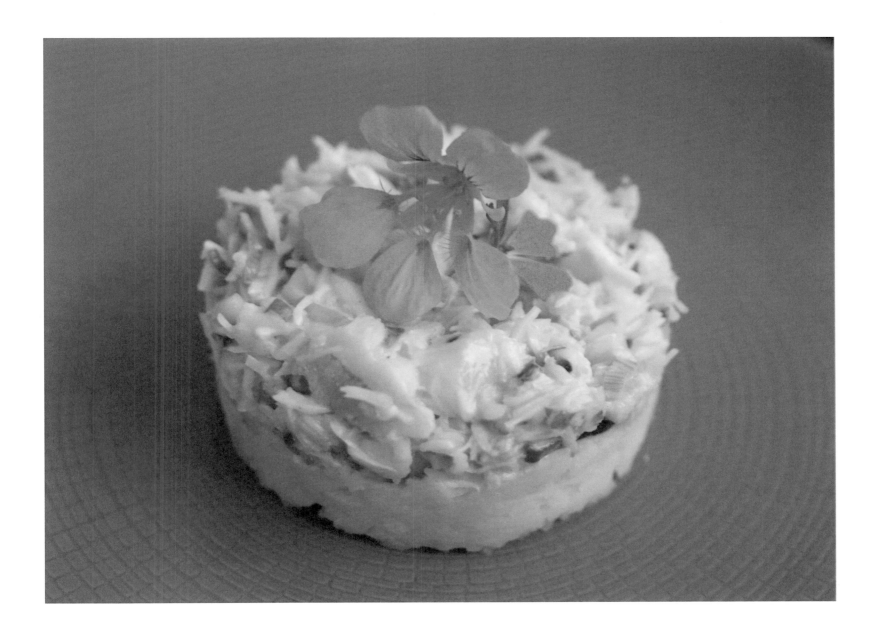

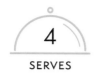

4

SERVES

French Onion Soup

INGREDIENTS

1 kilo of sweet white / yellow onion.
3 oz gruyere cheese
1 baguette
4 cups vegetable/ chicken stock
1 stick of butter
Garlic
3 bay leaves (fresh if possible)
Salt
Pepper
Nutmeg
2 small shallots
Herbs de Provence

INSTRUCTIONS

Making the croutons:

1. Slice the baguette normally into round slices, then cube these into 1cm x 1cm pieces. They will be covered in butter, so keep an eye out for any speciality flavours you may want to show off in these croutons. Once they are reasonably covered in melted butter, you can salt them and add thyme.

2. Spread them out more evenly at this point and put them in the oven at 200c for 10 minutes or until they are between golden and brown. Variation in texture is good. Once done, leave to the side. Don't refrigerate.

The soup:

1. Slice the onions and shallots into thin rounds, then halve these. Mince the garlic and brown in butter before adding the onions and shallots. These may take some time to sweat down and start to caramelise to the point we want. Don't worry, and don't turn the heat up.

2. You'll be adding butter at least three times during this process. With the onions absorbing much of it and hence adding richness to the soup later.

3. Add the three bay leaves once the onions have sweated down a little and are steaming. Notice that they won't absorb any more butter. This is the point we have been waiting for. You can now drain off excess butter from the onions with a china cap or by pouring.

4. Once the onions are incorporated into the stock, you can cut a hunk of gruyere and place it into the bottom of your oven-safe soup bowl or ramekins. Pour over the hot soup to help melt the cheese, and then pile on the croutons you made previously. Shave some parmesan onto these croutons and pop into the oven for 5-10 minutes to gratinate.

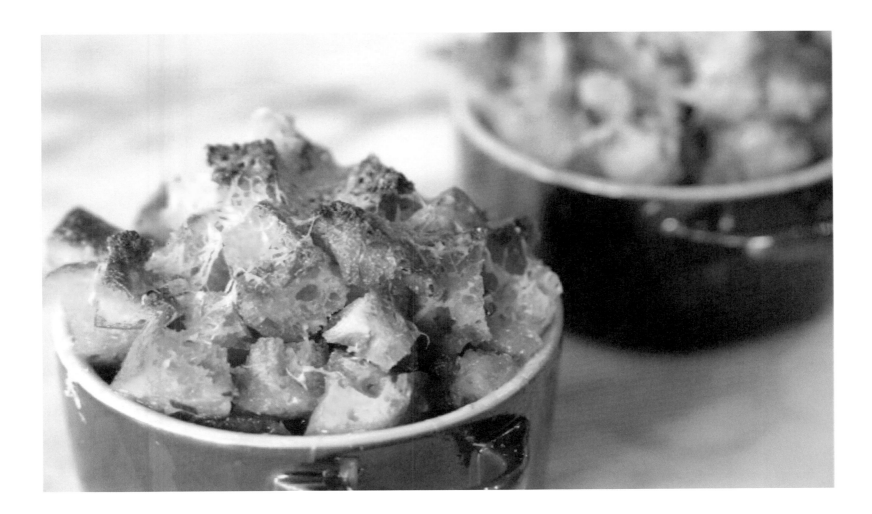

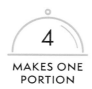

4

MAKES ONE PORTION

Stock Recipe for Soups

The sachet d'epices are a kind of bundle of aromatic and flavourful ingredients that give depth and dimension to stocks.

INGREDIENTS

250g carrot

250g parsnip

250g celery

Whole chicken carcass

Sachet d'epices

1 clove of garlic

Leek

Thyme sprig

Bay leaf

Clove

Pepper

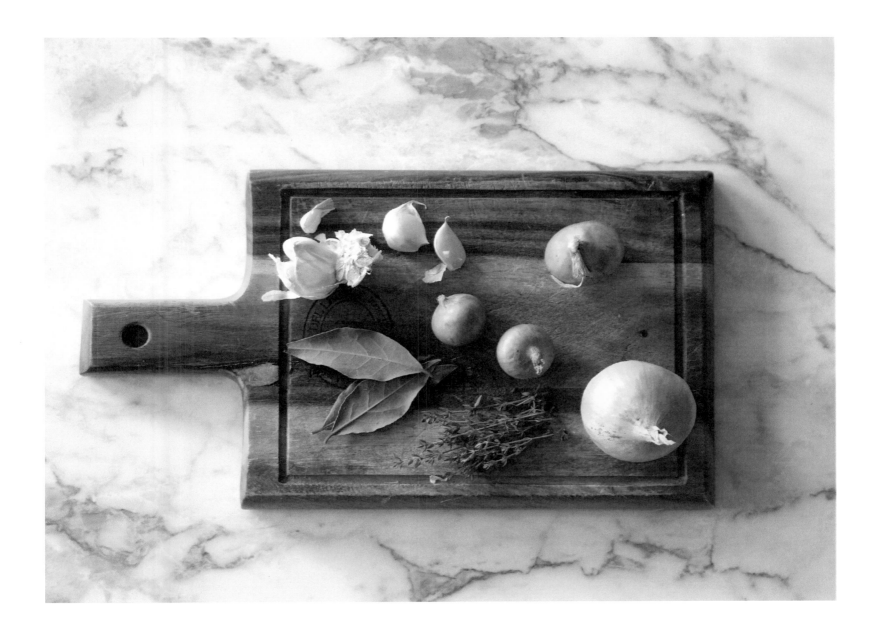

Cauliflower Salad

INGREDIENTS

1 large cauliflower
Pomegranate
Olive oil
Salt
Tarragon
Garlic
Orange

INSTRUCTIONS

1. Slice the cauliflower in half and place on a hot griddle with olive oil. Leave it for a few minutes until some char marks have started to form, and flip them to achieve the same on the other side as well. Add a few garlic cloves to the griddle and let them caramelise.

2. When done, take off the florets making sizes of roughly an inch all around. Don't discard the stem dice this into inch cubes.

3. Segment the orange, and prep the pomegranate. Combine the cauliflower, garlic and orange segments.

4. Finely chop the tarragon and zest a lemon being cautious to avoid the bitter white pith. Mix all the ingredients thoroughly in a serving bowl.

5. Finish with a dash of olive oil, a pinch of salt, and a crack of pepper.

Turmeric and Sweet Potato Soup

4
SERVES

INGREDIENTS

500g sweet orange
potatoes
Turmeric powder
Double
Cream
Garlic
Salt
Black pepper
Bay leaf
Parsley
½ litre mushroom stock

INSTRUCTIONS

1. Cut the potatoes into quarters and douse them with canola oil. Add the cloves of garlic around the potato with the bay leaf and some pepper and salt. Bake in an oven preheated to 200c for an hour or so. You can tell they're cooked when soft, and the flesh can be spooned away from the skins.

2. When this stage has been reached, scoop the flesh into a bowl and put the bay leaf, now caramelised garlic, oil and juices in with it. Add to this bowl 1 tbsp of turmeric.

3. Heat the mushroom stock until it's steaming, just about to boil, and add the vegetable mixture. Using a food processor, blitz until very smooth, and let this reach a light boil before adding 2 tbsp of double cream and blitzing in.

4. When serving, you can add a dash of extra virgin olive oil or cream over the top with a pinch of salt. A nice fresh green herb like parsley would be lovely sprinkled over the top.

2
SERVES

Garlic Shrimp

INGREDIENTS

10 tiger prawns or smaller
(heads on if possible)
½ stick of butter
3 garlic gloves
Black pepper
Salt

INSTRUCTIONS

1. Deshell the body of the shrimp, leaving the head on. Place them into a baking dish and sprinkle cubed pieces of butter around them with thinly sliced garlic. Crack some black pepper with a pinch of salt and place them into a preheated oven at 200c for 10-15 minutes.

2. Plate and douse with butter from the cooking dish, and don't forget the heads are a tasty treat!

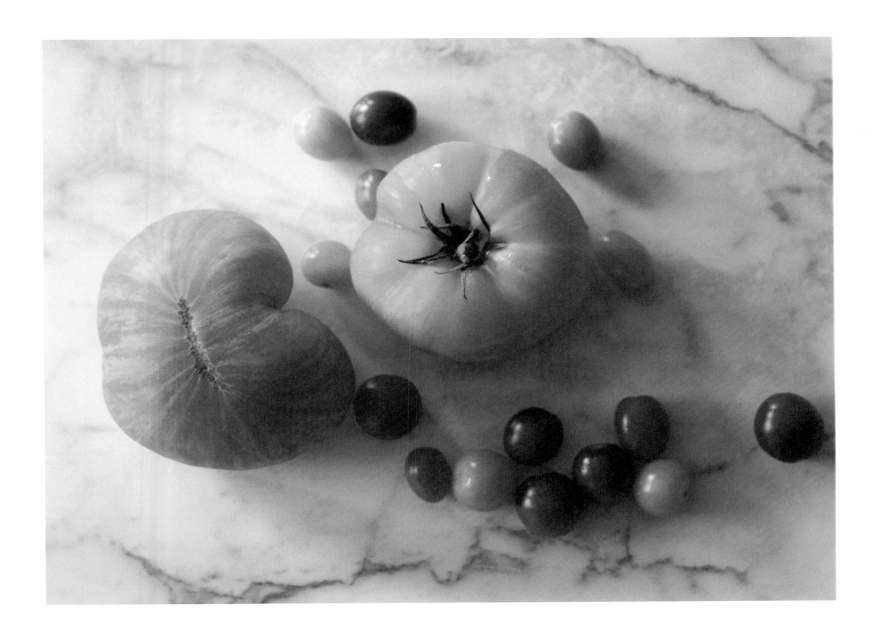

2-4

SERVES

Roast Chicken with Roasted Vegetables

INGREDIENTS

Medium size roasting chicken

Butter

Black or white pepper

Rosemary

Thyme

Honey

Lemon

Potatoes (roasting/baking)

Carrot

Leek

Onion/shallot

Garlic

INSTRUCTIONS

1. With a thoroughly defrosted or fresh chicken in a roasting tray, create two pockets under the breast skin. Be gentle; it will take a little practice. Get two knobs of butter and place these into the pockets you created. Throw some rosemary or thyme in there, also. This will crisp and infuse the skin while helping to keep the easily dried breast moist.

2. The lemons should be cut in half. If you want to be a little extra, you can caramelise the cut sides of the lemon before stuffing them into the chicken. Either way, it will keep the chicken moist from the inside while perfuming it with a lovely scent of lemon. Put some rosemary into the chicken with an onion or shallot.

Honey Glaze

INGREDIENTS

5 tbsp honey
Salt
Pepper
Rosemary

INSTRUCTIONS

1. Add a pinch of black pepper to 5 tbsp of honey and add a liberal amount of salt. You can add almost any seasoning you want to this, so think about what you like and what you have! Mix the honey and bits together until combined well and the honey is runny. Then slather over the chicken.

2. Have an oven preheated to 230c and place the chicken to cook. Use the rack of the roasting pan to keep it out of its juices. If you've room, add in your vegetables; otherwise, use a separate tray. Cover the vegetables in the chicken juices while cooking. Make sure to save all the juices from the chicken and vegetables, as this can and should be used to make gravy.

4

SERVES

Crab Mac and Cheese

INGREDIENTS

1 whole brown/
rock crab
250g cheddar
cheese
Black pepper
Salt
100ml cream
Macaroni pasta
Butter

Crumb:

Bread
Thyme/Rosemary/
Oregano
Butter
Garlic
Parmesan
(or other hard
cheese)

INSTRUCTIONS

1. Crab can be easily sourced from a fishmonger or market already broken down. Mix the crab meat with some pepper and salt. In a boiling pan, cook the pasta.

2. When the pasta is cooked, drain it and add in the crab meat with 100ml of cream. Incorporate these together, and then start adding cheese to the pasta mix. It will mostly melt down. Be generous with the cheese.

3. Once everything is combined, it can be poured into a baking dish roughly 10x7 inches and 5 inches deep. This is where the crumb will come in.

Crumb Method:

4. If you've stale bread lying around, that's perfect as you can break it down very finely into a crumb and hence avoid wastage. Use a cheese grater or stick some hunks into a tea towel and smash!

5. Add to this black pepper whatever classic herb you have, thyme or rosemary and then a little salt. Pour in enough olive oil to fully saturate the crumbs and combine the dry herbs. The oil will let the aromas of the herbs release. Sprinkle this over the mac and cheese and then grate over some of the parmesan or hard cheese.

6. As a side note, I always have the temptation of pushing little plum or cherry tomatoes into the top.

Pomelo and Mozzarella Salad

INGREDIENTS

½ Pomelo

2 balls of mozzarella

White balsamic vinegar

Pink and green
peppercorns

Extra virgin olive oil

Chive

Cilantro

INSTRUCTIONS

1. Segment the pomelo and throw it into a bowl. Slice the mozzarella thinly and lay it over a dish. Mince your herbs. Crush your peppercorns.

2. Add extra virgin olive oil to the pomelo in the bowl and lightly coat before adding this layer to the placed cheese. Sprinkle over peppercorns and herbs. Douse with white balsamic. (*regular can be fine; just be cautious of strength.*)

3. Ta-Da!

Italian Meat Sauce

2
SERVES

I say meat for two reasons; one, it's informal, like my days in northern Italy and two, it can be done with pork or beef or vegetarian mince. My choice is pork sausage meat. By no means traditional, by all means Italian. When you get used to making sauces, you'll find they can be made from almost anything lying around, reducing your wastage and providing an easy and quick meal. Peppers and tomatoes always form a great base to throw in fennel, garlic and onion. Beyond that, it can be creative and seasonal. The only rule is the creation of depth in flavour.

INGREDIENTS

Canola oil

8 medium red vine tomatoes

2 cloves of garlic

Oregano

Thyme

Bay leaves

2 red onion

200g minced meat

Black/white pepper

Parsley

Cup of stock

(mushroom works well)

Black Garlic (if able to source)

INSTRUCTIONS

1. Heat three tbsp of canola oil in a frying pan and add diced onions and minced garlic. Let this begin to caramelise. From here, add quartered tomatoes to the pan. Let these reduce down. If you have a food processor, leave your skins on for the depth of flavour (*umami*). If not, be aware these skins will be in your fished sauce, and you may wish to remove the tomato skins.

2. Add any dry herbs, salt and pepper. White peppercorns work well if you can find them, as do pink. Each provides a different permutation of pepper. Red and pink are floral, with long pepper being earthy. If you can find black garlic add this now after cutting into rough mince.

3. Let this all break down and combine on medium heat. When the tomatoes start to stick a little to the bottom of the pan, add a cup of stock and some bay leaves.

4. Fry off the mincemeat in a separate pan to give it a little colour, and then remove from the heat. Try to avoid cooking it all the way through.

5. When the vegetables have completely broken down, smooth the sauce with a food processor if you have, otherwise enjoy a more rustic affair. Add the browned-off meat to this and let it develop for an hour.

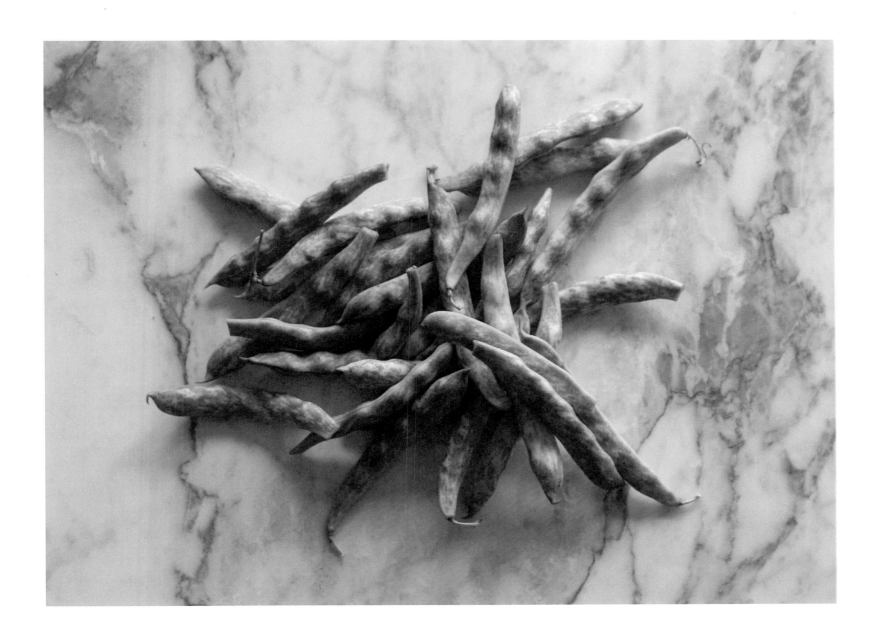

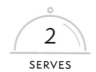

2

SERVES

Squash Soup

INGREDIENTS

1 kilo of any squash (acorn, butternut, delicate. The only one I would avoid would be spaghetti squash)

100g butter

Crème fraîche

2 cups of chicken stock (Vegetable stock can be used as a substitute)

3 cloves of garlic

5 fresh bay leaves

½ sweet yellow onion

Double cream

Thyme

½ Scotch bonnet pepper

1 tbsp of salt

Smoked salt (Maldon)

INSTRUCTIONS

1. Bake the squash with honey, bay leaves and thyme. This will take approximately an hour at 200c or to make simple – until it's mushy. Once this is done, throw it into a pot with a pot of crème fraîche. Using a soup maker combine the ingredients together and add 2-3 cups of stock.

2. In a separate pan, caramelise 1/2 sweet yellow onion and a clove of garlic. Finely mince 1/2 a small Scotch bonnet (*less if you prefer*). Add this to the onions for two minutes before adding the caramelised mixture to the soup mix. Using the food processor, blend this together until there are no definable bits.

3. Garnish with a splash of double cream in the centre, and a pinch of smoked salt once portioned into bowls.

Scallop and celeriac purée

INGREDIENTS

1 large celeriac

Butter

6 scallops

½ kilo Swiss chard

4 cloves of garlic

1 shallot

1l whole milk

5 ground peppercorns

1 tsp salt

INSTRUCTIONS

1. Bring the whole milk to a soft boil in a pan and add the skinned and cubed celeriac pieces. Be careful not to overheat the whole milk and cause curding.

2. The Swiss chard will need to be prepared and set aside. This involves cutting the large thick portions of leaf stems away. Heat a small frying pan with butter and add garlic with half the shallot finely diced. Once this has started to brown, you can add the chard. This will cook and wilt down quickly, around three minutes, to keep some vibrancy.

3. Turning your attention back to the celeriac, you will need to strain the milk keeping a small portion to one side, and then puree the celeriac with some shallot and garlic. Add the seasoning at this stage; 1 tsp of salt will do well.

4. As you puree the ingredients together, you can add some of the milk that was kept to one side to create the consistency you desire.

5. In a frying pan, add high-heat cooking oil such as rape seed or sunflower. Wait until you see the oil smoke just a little, and add your scallops. These will take roughly 1 minute on each side, depending on size. If they are hand-dived, 1.5 minutes will suffice. Small bay scallops, perhaps 45 seconds a side. Once they are cooked, lay them to rest on a paper towel.

6. To plate, make a bed of purée in the centre of the plate and put the scallops on top of this. The Swiss chard can be a straight side in a dish of its own or preferably next to the celeriac.

7. Believe it or not, this is a simple and quick dinner that never fails to please and impress.

4

SERVES

Beef Cheek Stew

INGREDIENTS

400g new potatoes
2500g beef cheeks
2 medium red onion
1 fennel bulb
Garlic
Butter
Salt
Pepper
Thyme
Bay leaf
Olive oil
1 Bottle of decent red wine
Flour
2 tbsp Worcestershire sauce
300g beef tomatoes
1 tbsp Dijon mustard

INSTRUCTIONS

1. Make a seasoned flour mix to coat the prepped beef cheek by adding salt and black pepper. Other meat rubs on hand can also work here.

2. Lightly coat the cheeks in the mix before browning off in a hot pan with rosemary. In another pan, reduce the minced red onion, fennel, and garlic. Once these have cooked down, you can add the tomatoes with 2 tbsp of Worcestershire sauce and one tbsp of Dijon mustard.

3. Reduce these down together, and when it has created a sauce-like texture that starts to glaze at the bottom of the pan, add the whole bottle of red wine. Let this simmer for a few minutes before pouring over the beef cheeks resting in a casserole dish. Cover the top of the dish with foil.

4. 45 minutes from the six-hour mark, it's time to boil the new potatoes. Do this by boiling water heavily seasoned with salt. Cook until they cleanly fall off a knife when prodded. Drain, butter, and crush!

5. Serve in large bowls, making a depression with the crushed potatoes for the meat and stew to nestle into. Sprinkle minced oregano with a crack of black pepper.

6. A hunk of bread goes perfectly with this!

MARKETPLACES

EACH AND EVERY city and often town has its own markets, if not multiple. In the U.K., we have historic markets town that only seem to come alive early in the morning on a weekend when produce is being brought out of the fields. These are the weekend markets, offering a range of vegetables and plants, most frequently with the odd butcher and fishmonger thrown in. These are small and really not designed for tourists, and that's the best aspect of them.

One example of this is the farmers market in Lewes on the south coast of England. It is only open on Sundays and is no larger than a tennis court. Yet it's these farmer's markets, not the whopping Borough market of London or la Boqueria in Barcelona, where I've encountered the biggest lobster I've ever seen. At these, you can also get homemade cakes and a slew of other delights. They showcase the local region in the best of ways.

On the other end of these are the large-scale food halls and markets, operating round the clock. A prime example would be de Foodhallen in Amsterdam. This was a weekly indulgence when I lived in the Netherlands. Its less focused on the ingredients and produce of the local area and rather exemplifies the food of the country. It shows off the diversity of cuisine held in the country and also has all the classics. To be succinct, you can get Dutch beer-flavoured Bitterballen and also Indonesian cuisine. Getting to taste the traditional food along with seeing the impact of the diverse immigrant communities is vital in understanding the make-up of a country, and this example does wonders in representing all the country and city of Amsterdam has to offer.

I cannot express enough adoration for the above-mentioned and my all-time favourite – Borough Market. It dates back to at least the 12th century and is by far the most comprehensive and incredible food market I've experienced in Europe, second to none. Operating all week, it brings in the finest produce from around the globe, harping back and continuing to represent London's power and dominance of trade. Coupled with the fine food angle is a magnitude of hot food stalls ranging from rotisserie pigs to oysters and urchins. It represents everything and everyone in London. An absolute staple where I'd do a biweekly shop. The people are amazing, and having relationships with many is one of the added bonuses of a site like this. Incomparable in size and nature, it is a must-see if you're in the capital and consider yourself a foodie. You will never be disappointed. Perch at a wine bar and watch the tourists plod on by gobbling down a treat or two.

No matter the scale or location, each marketplace has something of value to offer. Talk to the producers and stallholders. Never miss one if you're passing; you'll be sure to see, smell or taste something new and expand your palate.

FORAGING (U.K.)

HAVING THE ABILITY to forage in the U.K. is a delight. Mild winters yield an early spring laden with herbs, flowers, and vegetables. Coastlines come alive with sea beat (*the wild ancestor of all cultivated beats*), sea kale, and a multitude of saline herbs. As the year progresses, the pickings only get better, with trees full of fruit and nuts, bushes filled with berries, and an apothecary of herbs and flowers that become more and more prominent. Every spot seems to brim with an abundance of flavour and produce. Often in overwhelming bounty. It is an environment that creates a feeling of paradise.

Some of my favourite picks are water mint which is often found in clear shallow streams. The freshness is superb, and if you catch it in flower, you have an ingredient that is so effervescent it simply doesn't compare to anything from the grocery store. Plus, you will have the best mojito around! Thyme is another favourite herb. It grows in most grasslands, and the first sign you are near some is often the sweet herbaceous scent wafting up as you step on some – releasing its divine oils into the air. This is another point that makes foraging so great. It forces you to be in the moment and pay attention to your senses. A lovely bit of free therapy. It goes without saying that finding items in the wild for free that you know in the market would not be as fresh is a great feeling in itself...small victories!

The thing about foraging is that even if you don't live in the eden and plethora of the English countryside, you won't be left out. City parks have all kinds, and it is noted that morel mushrooms take to growing near human disturbance. In fact, I found two of the largest morels I've ever seen to date in the back garden of a rental which was a stone's throw from tower bridge and Shad Thames, London.

Not only that but on a larger scale, each country has its own variety. In Germany, they seem to covet nettles for bread and soup, something that I've adopted since my time there and is an absolute favourite. In Slovenia, they are out in the mists collecting mushrooms, and in the Netherlands, they adore chestnuts in the autumn. It is all about learning what is around you and when. Adding another layer of authenticity to life and food while making you feel more closely connected to where you are.

SWEETS & DESSERTS

6

SERVES

Banana Bread

Everyone has their own or has tried a banana bread recipe. It's great; who doesn't have bananas, flour, and egg? Every deli and pastry shop in London has its own version. Some dry, some not, some with real flavour, some lacking. Like those, yours will be trial and error. Consider banana bread the gateway drug of the baking world.

INGREDIENTS

6 overripe Bananas
1½ cups flour
2 eggs (beaten)
1 tsp brown/coconut Sugar
1 tsp baking Soda
1 vanilla pod
½ cup unsalted butter
1-2 tbsp crème fraiche/ live yoghurt

INSTRUCTIONS

1. Preheat oven to180c.

2. Mix the sugar and butter until creamed. Once this is done, add the eggs and crushed bananas. A tip is to beat the eggs before adding. Once this is combined, add the baking soda, vanilla pod, and a tiny pinch of salt if needed.

3. Using individual loaf tins as always, portion out the mix filling the buttered tins two-thirds the way up and bake for 45 minutes.

4. To check they are cooked, open the oven 10 minutes before the 45-minute mark and jab with a toothpick. If it comes out of the cake clean, you can be assured it is cooked. Do not open and close the oven.

Citrus chocolate cake with honied lavender whipped cream

INGREDIENTS

1 cup flour

1 cup caster sugar

3 eggs

60g cocoa powder

2 limes

2 lemons

2 oranges

1 cup butter

INSTRUCTIONS

1. Preheat the oven to 170c, and butter some small cake/muffin tins.

2. When combining the ingredients start with wet, cream the butter and sugar into a smooth mixture then add the eggs. Slowly add the four using a sieve to break down chunks and provide an even flow. The flour should then be folded into the mix. The eggs should also be added one at a time and be incorporated well before the next is added.

3. They will bake in the oven at 170c for 20 minutes. Jab a toothpick in to make sure it's fully baked. They should have risen a little.

Peach and Mango Loaf Cake

This is inspired by those first few months of summer. When June turns into July, the first tree-ripened peaches and nectarines start coming in from Italy and Spain, mangos are also in season, and it's irresistible if you have a sweet tooth to combine these two into the perfect fruity sweet summer treat.

INGREDIENTS

2-3 ripe peaches
2 small ripe mangos
½ cup unsalted butter
1 cup coconut/brown sugar
2 eggs
1½ cups flour
1 tsp baking soda
½ tsp fine salt
1 Vanilla pod

INSTRUCTIONS

1. Preheat oven to 180c. Mix the sugar and butter together until smooth. Beat the eggs before adding these next. Once that's incorporated, add in the mashed and diced fruit. Lastly, add the flour, salt, and baking soda.

2. Mix until combined but don't overwork the mixture. Portion into muffin or individual baking tins and cook for 45 minutes. If you use an 8 x 10 baking tray, it will take about an hour to cook.

18-20
BISCUITS

Peanut butter biscuits

INGREDIENTS

1 cup chunky peanut butter
2 medium eggs
1 cup butter
½ cup jaggery
1 tsp baking powder
1 tsp baking powder
2.5 cups flour

INSTRUCTIONS

1. Combine the peanut butter, both sugars and butter, until this is a smooth consistency.

2. Add the eggs one at a time until they have been fully incorporated into the mixture. Add the baking soda and powder.

3. Last but not least, add the flour to the food mixer. Do this slowly at a low speed to avoid it being flung up everywhere.

4. Using your hands, form a sphere with the dough that should fit comfortably in the palm of your hand – no tennis balls but something like a small golf ball. We are going for a large biscuit – a loophole for claiming you've only had one!

5. These can maybe fit 6 on a large baking sheet.

6. They should cook for around 20 minutes at 200c. Make sure they are cooked to be GBD or '*golden brown and Delicious.*' They will be more like a biscuit than a cookie, as they will be crunchy and crumbly.

7. Making sure that these cookies are baked beautifully is crucial, as the crunchy bits in the peanut butter will want to brown and take on a wonderful roast peanut flavour.

8. Once they have baked for 20 minutes and you have made sure they are baked to have some colour, let them sit for 10 minutes before enjoying them.

Apple & Rhubarb Crumble

2-4
SERVES

INGREDIENTS

200g flour
100g sugar
100g butter
1 small apple per crumble
300g rhubarb
Nutmeg
Lemon zest

INSTRUCTIONS

1. First, make a crumb. This will be done by adding flour, sugar and butter together. It is a feeling when the mixture is of the right consistency. It will be dry and hold some shape and form but, as the name suggests – crumble. It is hard to always know how much you want, and as the crumb will last for some days, I often overmake so that there is some easily accessible if I need a quick and delish late-night treat.

2. Once you are happy with the consistency, I find putting the crumble into the fridge for 20 minutes will harden the butter and make sure the crumb holds its shape when cooking rather than melting and becoming a claggy mess.

3. Slice the apples and rhubarb roughly and fill the baking dishes. If you'd rather do a whole 8 x 12-inch crumble, just fill up a whole dish with the fruit. You will want to fill it all the way to the edge as the cooking process will reduce the fruit.

4. Cook for about 20–30 minutes at 190c. When the fruit starts to bubble and become sticky, it is done!

5. A great side with a crumble is some vanilla ice cream. Hot and cold always work well in a dessert, and this is no exception.

6. The great thing about a crumble is it can be done with most fruit on hand. In blackberry season, for example, I will exclusively use berries and apples. The only thing to stay away from would be very wet fruit like ripe plums or citrus, as the water content will ruin the crumb.

INDIVIDUAL
PORTION

Tea soaked oats

INGREDIENTS

100g oats

1 tbsp honey

Black tea

Water

Palm/brown/coconut sugar

INSTRUCTIONS

1. Make a cup of black tea, not too strong. Add this to the oats and let them absorb. Checking the consistency if more liquid is needed. Once the oats have expanded, add a tbsp of honey and sprinkle with your sugar.

Blackberry/bramble coulis

MAKES 500ML

Go out and find some bramble or blackberry bushes in the August heat. When you've had enough of manically picking between the thorns, you'll be ready to indulge with this high summer treat. A must-have for pancakes, Greek yoghurt or cake sauce.

INGREDIENTS

400g blackberry/bramble
125ml water
75g coconut/brown sugar

INSTRUCTIONS

1. It's really best to use coconut sugar for this as it creates a wonderful rich deep flavour that marries with the berries sublimely.

2. Into a saucepan, add the water, sugar and fruit. Bring this to a light simmer and cook for around 15 minutes until the fruit has broken down and you've got a thickened consistency. Blitz it with a food processor and then pass it through a fine sieve to remove any seeds and fruit skin.

3. Bottle up and enjoy; it will last about a week.

12

SERVES

Marshmallow Biscuits

These are a silly mistake that I actually adore. The marshmallow will melt and create this biscuit snap. The longer you cook, the more caramelised and more snap will occur a shorter bake will result in a chewy cookie-like feel. So have fun and find your texture.

INGREDIENTS

200g mini marshmallow
1 egg
1 yolk
200g coconut/brown sugar
200 butter (melted)
300g flour
1 vanilla pod

INSTRUCTIONS

1. Combine the sugar and butter. Add the egg and vanilla, combining all these ingredients thoroughly. Add in all remaining dry ingredients.

2. Preheat oven to 180c, and when ready, bake for 20 minutes. Let them cool for 10 minutes, and they will be ready to scoff!

Plum Cake

4

SERVES

A delish treat for the turning months when summer yields its labours, and we start to think about warm spice and stone fruit pies. There are a plethora of plums if you go to any fresh food market. Little greeny yellow ones, dark purple juicy ones and a slew of inbetweeners, all with a unique flavour. Find your favourite.

INGREDIENTS

7 plums

140g flour

2 eggs

1 tsp baking soda

115g butter

150g sugar (brown/coconut)

Cinnamon

Nutmeg

Lemon zest

INSTRUCTIONS

1. Treat the plums like a tomato and blanch them to remove the skins easier. This should take no longer than 2 minutes. Peel the skins and cut the flesh from the plum pit.

2. Chop the plum flesh roughly. Add the lemon, nutmeg and cinnamon.

3. Mix the butter and sugar until smooth, and then add the flour and baking soda. Lastly, add in the eggs, followed by fruit. Mix these thoroughly. Place into muffin moulds or small cake tins 4 x 4 x 2 inches roughly.

4. Bake for 45 minutes at 170c.

5. Make sure not to add any juice from the plum flesh. This will naturally be luscious and wet, but when baked right will be light.

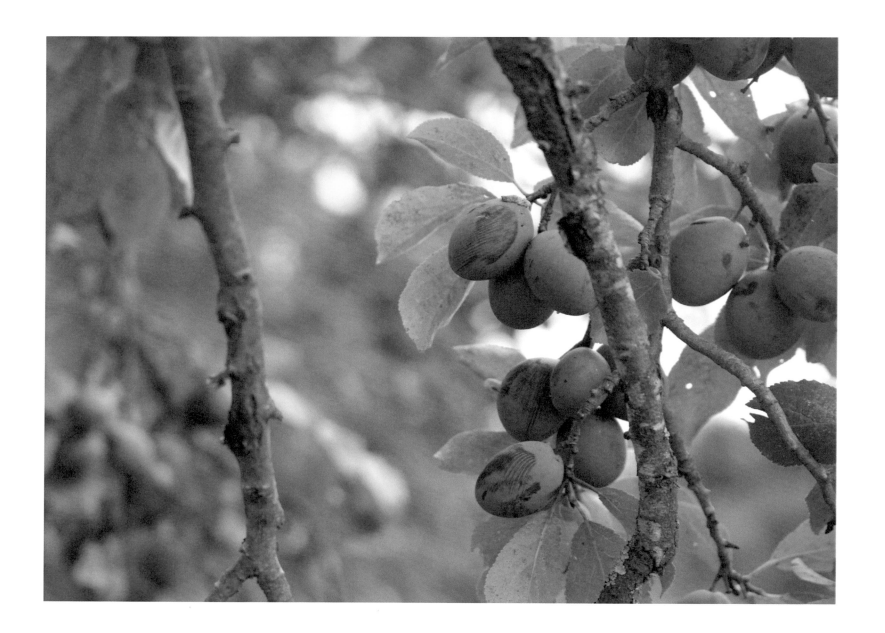

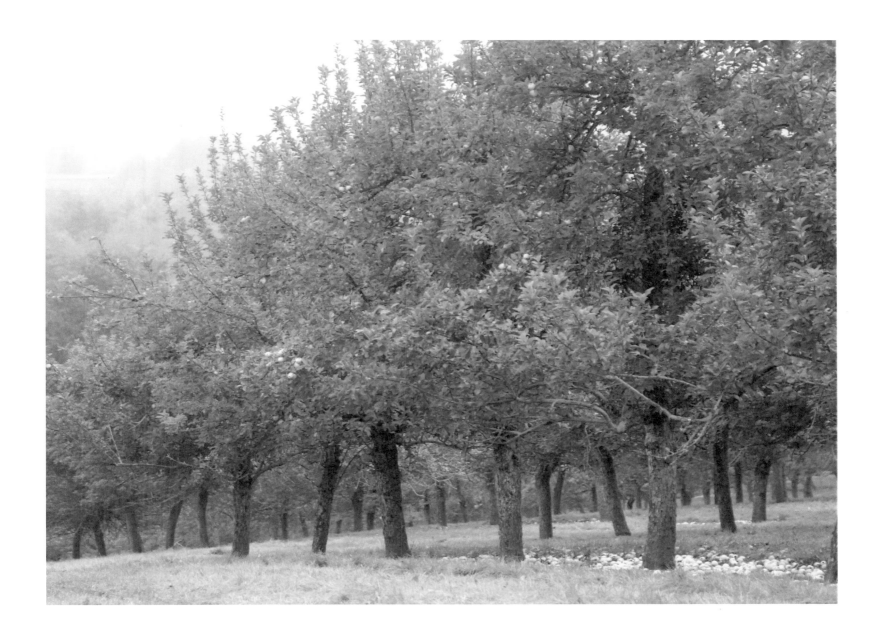

DRINKS & INFUSIONS

Infused Alcohols

THE INFUSION OF ALCOHOL is a worldwide pastime, but in Europe, it's utterly mastered by all. The Germans love schnapps, which the French would call brandy, and the Italians call grappa. These are brandy or 'Eau de vie' alcohols, and they utilise the wild or grown heritage fruits of a region. The French have an affinity for pear, the Germans cherry, and in England, we love a good sloe berry gin. They are, in effect, the same form of alcohol, a clear white spirit made expertly with hundreds of years of knowledge. Or, in my case, muddling some sloes and gin together and hoping for the best the following year – we all start somewhere!

These are liqueurs not to be mixed into a cocktail but traditionally sipped on as is. This is how you get the best aroma coming through. The reason for its importance is that it's an expression of local fruit growing and distillation skills all in one sip. Depending on region or country, they also serve a select purpose. For example, in Portugal, the sipping of Ginja, a wild cherry-flavoured tipple, can take place at any time of day, morning or night and is best had in sets of threes, I find. However, up north, I've often been sent on my way after a quick sip of schnapps. Most notable was a two-star Michelin restaurant on the Elbe River in Hamburg. The flavour was that of carrot, yes carrot, and being asked to identify this after a whole meal and pairings of wine was wholly unfair but enjoyable nonetheless.

That raises the next and most obvious point of why these infusions are important. They bring people together over the enjoyment of flavour and local traditions. They represent regions and growing areas, and they also provide a great opportunity to learn about a culture and what makes them tick in certain regards. Plus, who in their right mind doesn't like a little buzz to relax the mind and create a free flow chatting up some locals.

Autumn Leaf

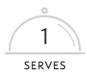

INGREDIENTS

Fever tree Mediterranean tonic
Triple Sec (Kew Orangery)
Palm sugar
Rose petals
Cinnamon stick

INSTRUCTIONS

1. This is a drink that's both refreshing and warming at the same time, perfect for the in-between days that autumn brings us. Not only does it look stunning and smell even better it can be tailored to you. Strength is variable to the day and mood. Cold and bitter...make it a three-pour. Just need a tipple...make it a double.

2. Pour 50-75ml (2-3 shots) of the triple sec into a whisky/Tom Collins glass with crushed ice. Then add the palm sugar, which will begin to slightly dissolve in the alcohol. This is what will cause the drink to have a slight gradation in colour, as this will mostly sit toward the bottom of the drink.

3. If possible, char the cinnamon stick with a blow torch as this will create an aromatic smoke and more flavour to impart into the drink. Use it to stir the drink regardless of whether it is being torched or not. Leave the stick in and top it off with the fever tree tonic. Sprinkle a few rose petals for aroma, and it is ready to enjoy!

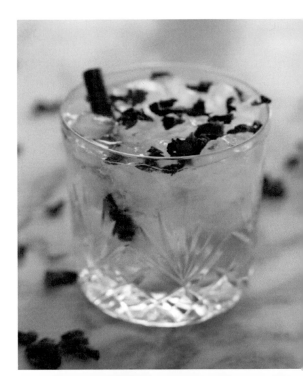

4. Serve with ice. This is a true showstopper, oozing sensuality. It's sure to impress anyone!

Earl Grey and Peach Vodka Lazers

For those hot summer days spent lazing wherever, whenever.

INGREDIENTS

1 litre vodka
Earl grey tea
2-4 ripe peaches
Elderflower tonic
1 lime

INSTRUCTIONS

1. Peel the peaches and muddle them with the vodka in a bowl for 30 minutes. Separate the two and put a tbsp of the muddled peach in the bottom. Fill the glass with ice and squeeze over half a lime. Pour in 240ml of the peach-infused vodka and top off with elderflower tonic water. Regular can also work fine.

2. Zest a little lime over the top for some extra aromatics.

London Zen

INGREDIENTS

1oz green tea liqueur
1oz London dry gin
3oz sparkling Limonata
1 lemon twist

INSTRUCTIONS

1. Serve in a champagne flute or coupe.

2. Mix the gin and liqueur over ice before pouring it into your glass. Add the lemon twist and top off with a sparkling lemon-flavoured drink of a well-known Italian nature.

3. A great summer tipple, though, don't have too many!

Rose lemonade

Because who doesn't need something refreshing for the spring and summer months. If you are smart enough to spike it with gin or vodka, you'll find the days lazed away.

INGREDIENTS

50g rose petals
¾ cup lemon juice.
¼ cup orange juice.
½ cup sugar
6 cups water

INSTRUCTIONS

1. Dissolve the sugar in water and add the rose petals to steep. This will take roughly an hour. Stir the mix occasionally.

2. After an hour, add the lemon and orange juices. Add ice, stir and enjoy!

Peppercorn G&T

A no-frills drink! Used by British sailors to ward off malaria in tropical lands. Quinine derived from a tree was a less than satisfactory drink, so the only real solution in that scenario is to reach into the Navy strength gin barrel. In regard to this drink, it's simply four ingredients and ice. This means it all lies in the method.

INGREDIENTS

*5-10 peppercorns
(black is fine, but pink
is far more floral)
1 lime
50ml London dry gin
Tonic water
(with quinine)
Ice*

INSTRUCTIONS

1. A proper tonic really is a must. My usual favourite, due to the authenticity of ingredients, has become a sticky, sugary drink which is extremely unpleasant. There are a few out there, however!

2. Remove two thin layers of lime rind and then cut in half, squeezing one-half over the ice in the glass.

3. Add 5-10 peppercorns, do not grind or crush them.

4. Pour in 50ml of gin because it sounds better than saying a double shot, and top off with tonic.

5. Now with the lime rind, take one and fold it green side in over the ice cubes and watch the skin explode with fragrant oils onto the ice as the bubbles from the tonic release it back up off the drink itself. With the second piece of lime rind, fold the skin over the ice much more gently. You are trying to ooze the oils out rather than project them. You'll be able to see the shiny oils, and this should be rubbed around the rim of the glass. The effervescence is utterly sublime.

Geranium Infused Oil

As stated, you can infuse oils with pretty much anything for anything. I specifically like to encourage geranium use because it's a plant we all know, love and have probably grown at one point or another. It's this concept people think can only occur when you're out in the country with a garden, but these are pot herbs and incredibly strong, so a little goes a long way. There are also so many varieties with so many aromas you can enjoy finding and growing your favourite.

INGREDIENTS

3 fresh Geranium leaves of your choice
Olive oil/extra virgin canola oil

INSTRUCTIONS

1. Slap the leaves once or twice on each side after they have wilted just a touch and fit into a bottle. Fill with an oil of your choice and leave for at least a week.

Infusing Sugars

Vanilla and lavender are most commonly chosen for infusing. There are endless uses, from breakfast to baking or elevating your drinks game!

INGREDIENTS

250g granulated sugar
1 used vanilla pod
250g granulated sugar
2-3 fresh lavender flower heads
3-4 infusing dried flowers

INSTRUCTIONS

1. Pour the sugar into a jar and push in the vanilla pod or lavender and leave for a week before use.

Wild Garlic Oil

1
LITRE BOTTLE

When infusing, we always want to get the best ingredients we can. These can be wild-foraged or store-bought. The quality of the flavour is highly important to create a punchy flavour in the end product.

INGREDIENTS

Garlic (Wild) or three cloves of garlic
1 litre extra virgin Olive Oil

INFUSION METHOD

1. Take five leaves of wild garlic or three cloves of garlic. If using leaves, place them in your palm and slap them as if you were clapping three times. This will break the leaves down, enabling the oils and flavours to infuse. If you're using garlic cloves, just crush the three cloves with the palm of your hand and take the dry skins off. They should be slightly crushed from this and ready to put in a bottle and pour your extra virgin olive oil in.

2. While simple, there are many variables. No two olive oils taste the same – some green and bitter, some floral – keep this in mind and try tasting if you can before buying.

3. This infusion method is a template for all fresh herb infusions. Try a mix or make an infusion with your favourite herb.